Capturing the Smoky Mountains

Authored

By: Lynn Phelps

Copyright 2013 Lynn Phelps

A Guide to Photography in the Smoky Mountains

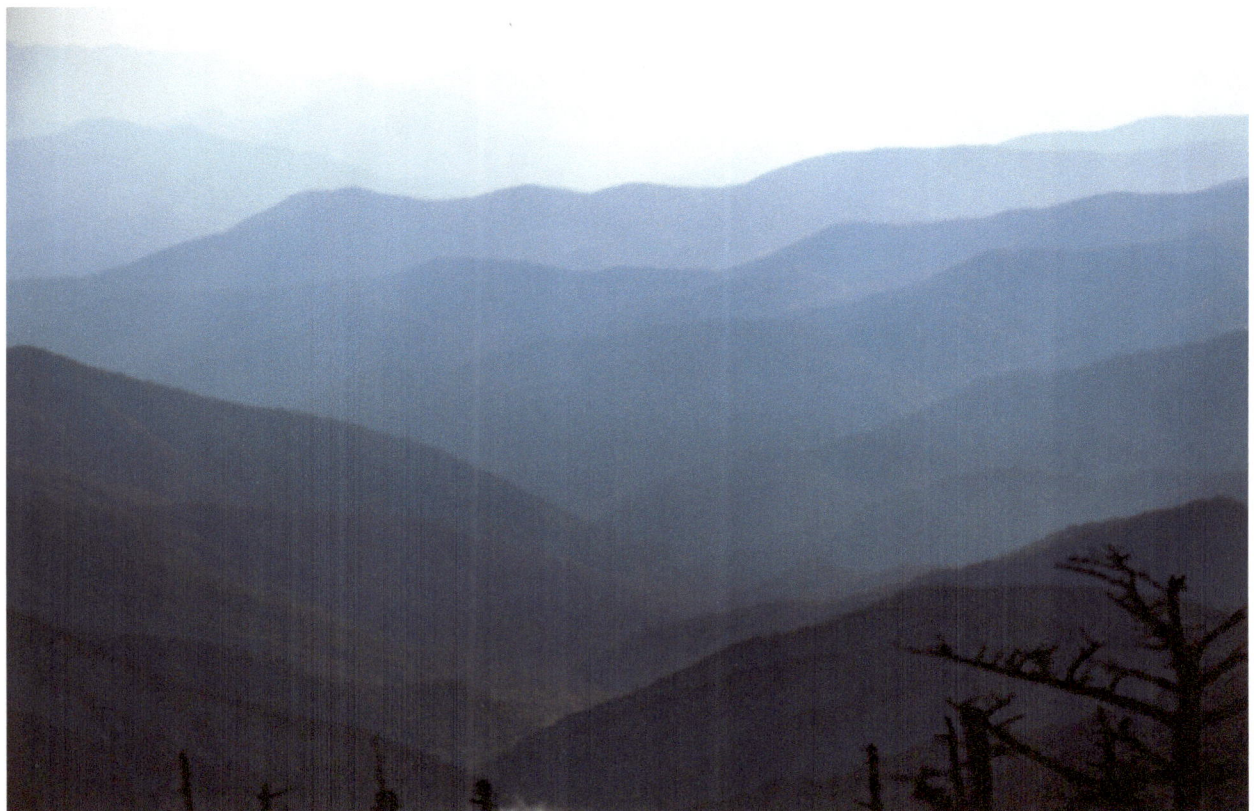

 This guide is written and dedicated to the love I have the Smokies and my ancestry the Ramsey family and the Spence family. After capturing the Smokies alone for many years I can honestly say that its much more fun with a group of other photographers. Which is why we now have group trips. Check us out at www.photographyshootingtrips.com. We would love for you to come with us. I hesitated on including photo's because the quality will certainly become diminished in ebook form but I felt that it is important. If you would like to see my work please visit www.lynnphelps.com At the end of most sections you will find a fun project to do so make sure to take this guide with you if you decide to do this alone.

Please be aware that you will be entering bear country. The bears are not tame, they are not restrained, and they can be dangerous. Please refer to the information in the reference section on how to protect yourself if you encounter a bear.

Capturing the Heritage

Capturing Wildlife

Capturing the Smoke

Capturing Sunrises and Sunsets

Capturing the Seasons

Capturing Reflections

Capturing the Night

Resources and Guides

Capturing the Heritage

As a child I was intrigued by stories of my heritage. I had two pets named "Smoky" and I was fascinated by the mountains. So it is only right that I want to capture them and share what I see through my lens with all of you, in a way that only a photographer can "see".

In this book I will share photos, the places to capture these photos, a few hints and perhaps a warning or two, along with some practical advice for planning your trip including places to eat, and places to stay. This is not a how to book, but a where to book. There are plenty of how to books already written in regards to the Smokies. So let's begin with setting the mood for capturing the heritage of The Great Smoky Mountains.

The Smokies are named because of the blue mist or fog that lays across the tops of the mountains. This fog or mist is a natural beauty that happens because of the streams and rivers. The Smokies are among the oldest mountains in world and the highest in the Appalachians.

Tip: If you are shooting near any of the rivers, or streams or mountains make sure you have a lot of extra micro fiber clothes and keep your gear wiped down at the end of each shoot. Also bring rain gear, at any given moment it could rain.

Gatlinburg was originally known as White Oak Flats. You may see that name pop up a time or two. Some things to look for if you are capturing the heritage would be old willow trees or white oak trees, and mountain laurels.

Yes that is me a very long time ago under the willow tree.

The ancestry of the Smokies is Scotch-Irish and Cherokee. I am both. I am very proud of my ancestry because they were one of the first 6 settlers and they struggled hard and long to get to

America and then to settle into the Smokies. Most local folks have lived through a lot of hard times. It used to be that you would find homemade and hand crafted items, now there is only one place to go to find those so if you want to experience the heritage you'll want to go to Arts and Crafts community off of Highway 321. There you will find homemade and handmade and perhaps some blue grass music being played, and would make great local heritage photos. Last time I was there I counted over 70 local crafts people.

There are many places to consider for photography within the national park but the national park doesn't just stop and end in one place. It isn't just a straight road up to the top and back down. In addition to other National Park areas there are also many local areas where you can take time to create and compose that perfect photo. For instance a trip down Wears Valley Road will bring you to some local crafter shops and antique stores and as of this writing June 2013 they still exist and are the real thing. Look for handmade quilts, you may even be able to ask the lady who put it together to stand in the picture with her quilt. A quilt can take one to two years to make if completely hand sewn. Along some of the back rounds like those in Richardson's Cove where I am from you may find wooden plank bridges, covered bridges and plenty of cool hollow roads.

The National Park consists of 520,000 acres and has thousands of species of animals, birds, flowers, plants, trees, and insects not found anywhere else. You could spend time just hunting those if you wanted to come back with some unique and rare macro shots. There are many opportunities for capturing great wildlife photography from turkeys to bears. If you spot a red wolf the photo might be worth some money because they were introduced into the area but most

did not survive. However the Peregrine falcon and river otter have been brought back successfully.

Tip: Wildlife photography is best done at sun up and dusk. Most animals sleep in cool spots on hot days and feed during the cool hours of sunup and dusk. More on wildlife later.

Music was influenced in the area by Scotch Irish immigrants what we know today as blue grass. Music is part of the heritage trail. You can find more information about that and also perhaps some willow baskets that are also native to the area at Arrowmont.

Tip: You will want to stop by Arrowmont on your break it's a wonderful center for artists located right in Gatlinburg. They have photography workshops and you can stay there free if you provide a workshop (rules may have changed). But check them out, they have been around since 1945.

There are plenty legends and folklores, moon lit dirt roads and ghost stories that can get you into the creative spirit of things. One thing that I find very fascinating is that every June without fail the fire flies blink in a synchronized dance. For about a week beginning around June 6th. You can catch a shuttle from the Sugar lands Visitor center.
http://www.nps.gov/grsm/naturescience/fireflies.htm

I hope that this brief chapter on capturing the Heritage puts you in the mood for some great shots. If not then pick up a CD of mountain music, and stop by the locally owned and run Mountain House Restaurant located on Hwy 321 only open for breakfast and lunch and ask for the biscuits and gravy! Of course after that meal you won't feel like shooting.

Capturing Wildlife in the Smokies

Sometime between 2000 and 2001 there was a news story about a woman who was mauled to death by a bear in Cades Cove. She had photos of the bear on her camera. Do I have your attention? Cades Cove, my ancestors lived is truly a paradise for photographers, but the animals that pass through and live in Cades Cove are wild! It's not a petting zoo they are not tame. I've been bear spotting for quite some time now and I have seen a lot of scary things. Bears are sometimes easy to spot and sometimes not. Even if you are not looking for bears you need to know the following information because there are a lot of them in the Smokies.

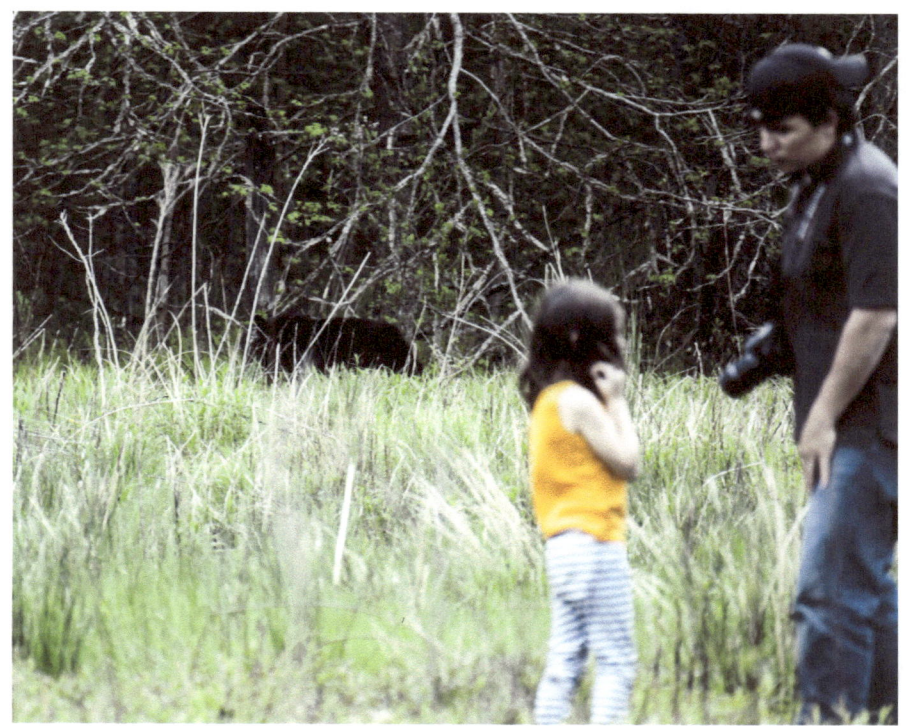

I intentionally blurred out the people so that the focus would be on the bear as I was backing away back to my car, and I was far enough away to shoot it with a 300mm. This is a great example of what not to do. He wanted the picture of the bear, his daughter was scared.

A bear can run up to 45 miles per hour.

So let's say that you are going hiking you should have a horn. You can get one at Walmart that will fit in your pocket. **Pepper spray ladies doesn't hurt either but not for those bears**. If you happen upon a bear do not run!! Do not!! Instead back away slowly, don't make eye contact. If the bear stomps its front paws then you need to appear bigger than a bear. Bigger and louder hands over head wave them with the horn. Bears can climb trees, swim, and run FAST. If the bear isn't stomping its paws then just keep moving slowly backwards. Also playing dead only works around grizzly's not black bears. Don't play dead, if you are attacked fight with everything that you have.

If you are photographing a bear you should stay about 100 yards away and you will know if you are too close if the bears activity changes. For example if it stops eating and looks at you, or stomps its foot. Then you are too close. So what's the easiest way to spot a bear in the cove? Easy, look for a bear jam! A bear jam is when you are driving down the road and suddenly you can't go anywhere because cars are stopped, pulled over, car doors are flung open and it looks like the apocalypse happened. But if you look over into the field you will see people with cameras, and some making mistakes like the picture before. That's the easiest way but the best way is to show up at sun up or at dusk. Look high in oak trees where they like to sleep, or around wild cherry trees in late July or August. They love wild cherries and other berries. Take a side road in the cove and drive slow. Get out and walk a bit, or go for a hike. I'll include a link about bear country in the resources section at the end of this book. Be sure to check it out.

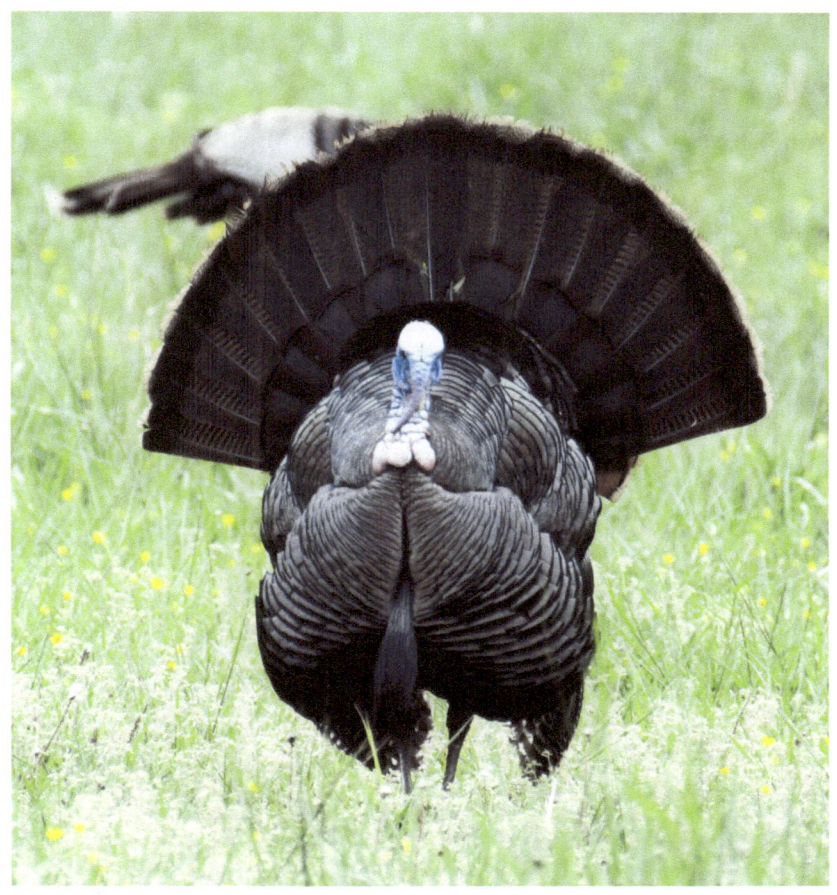

Of course there are plenty of other animals to capture. White tailed deer and elk for example. If you see some in a field you could position yourself and wait to capture one jumping over a fence. They are conditioned to cars and often times you can get a great shot, I haven't ever seen anyone using a blind. In the fall you might see two bucks knocking around. In the spring turkeys doing mating dances. You'll also find plenty of other photographers dressed out in camo or khakis waiting for that perfect moment.

When you first enter the Cades Cove area you will see horses to your left, they are semi wild and when they run all together they are simply beautiful. Just beyond that you will begin seeing turkeys, elk, and other birds. There has been for the past three years a pileated wood pecker. He

has teased me relentlessly. I have found that most of the other animals are deeper in the cove after the middle.

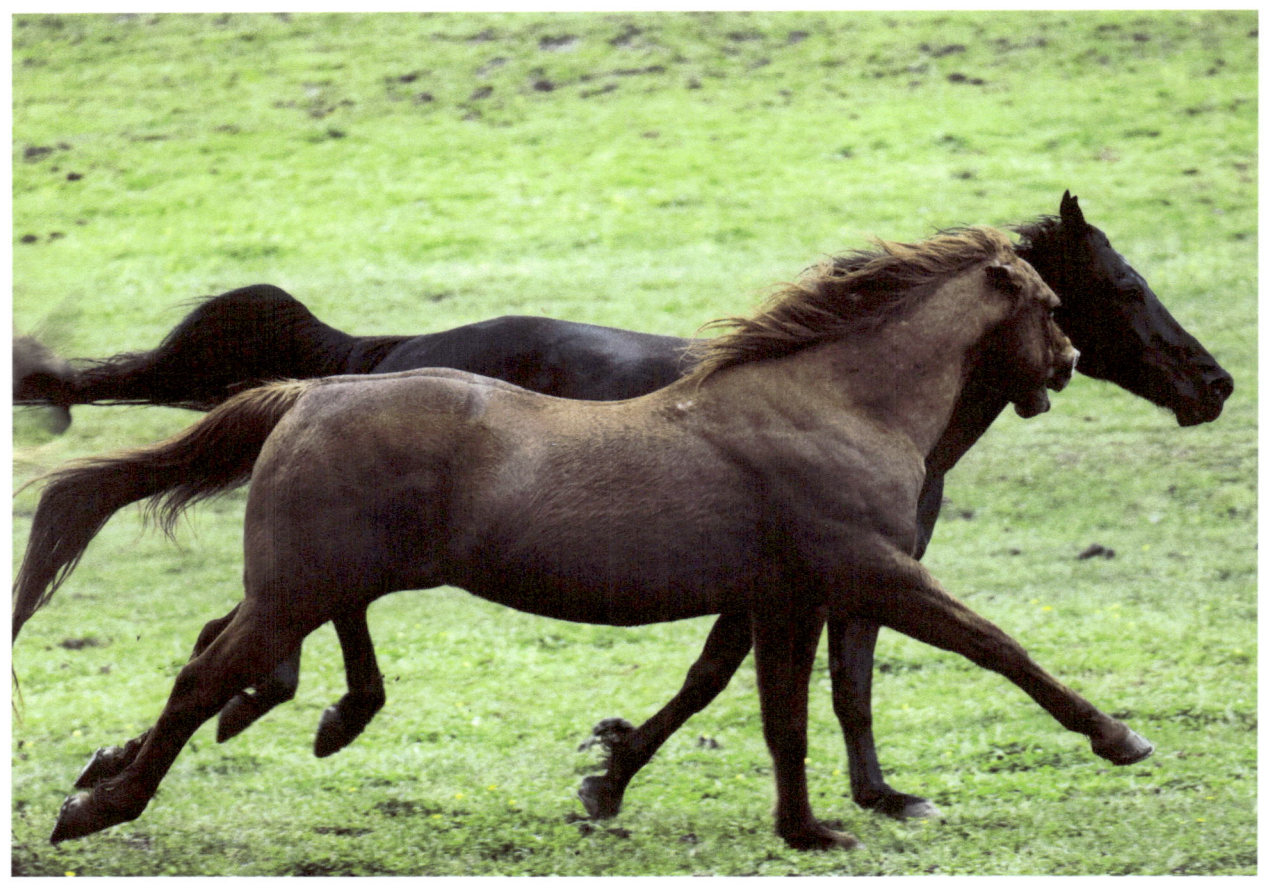

Tip: I've shot with both a 200mm and 300mm and a wide angle. I found the 200mm is pretty much useless unless the animal gets right in the car with me. The 300mm gets great shots without having to get too close. But if you could bring a 500 you'll get the shots that everyone else misses.

Smoky Mountain rain, there is a country song with that title for a reason. Dress out your gear and take a long a rain coat the animals there love the rain, as long as it isn't a torrential

downpour. The plus side- while you are out in the rain waiting for that perfect pause in the drops everyone else will be back on Townsend drinking hot coffee, but you will be alone and that in itself is worth it so take a thermos.

Rules and laws for wild life photography. In the rules they specifically mention photographers, I think we have a bad rap. Please use pull offs when viewing wildlife or park in a parking area and walk. You can also rent a bike and on Wednesday and Saturday mornings they allow only people on foot and bikes until 10 AM but that might be a bit cumbersome with gear. Do not feed or disturb wildlife it could result in fines and jail time. The rangers take federal regulations very seriously. Cataloochee Valley is another place to find wildlife and if you want to be in a quieter area then this is the place to visit. Unlike the 11 mile loop at Cades Cove Cataloochee is a long winding road I have not been there any many years. So if you are prone to car sickness or like me vertigo stick to the cove.

Don't forget animals love nature's food not your food, please don't feed the wild life.

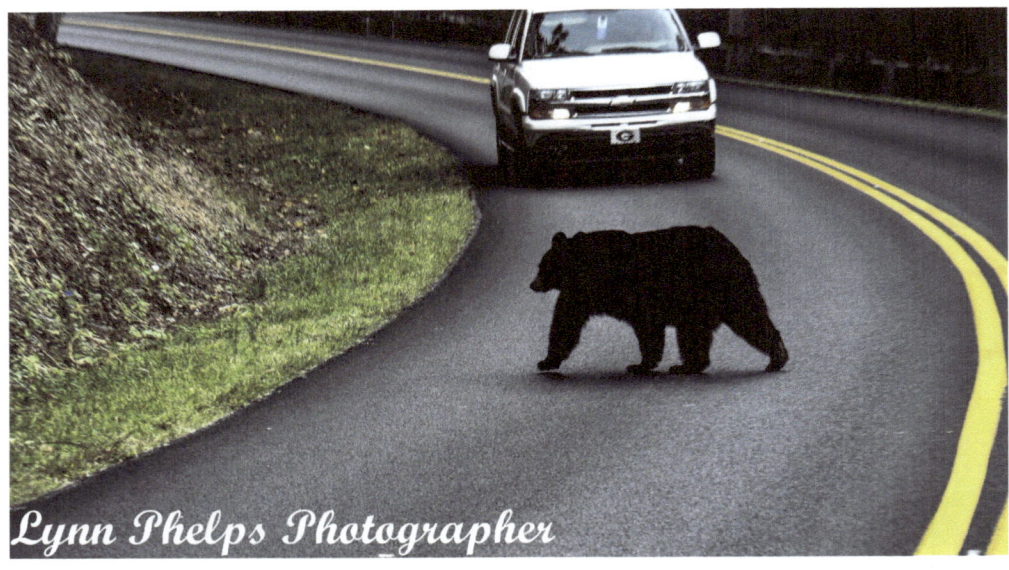

There are many other opportunities to see wildlife and if you don't then don't give up hope because on your way home you just might have a bear run out in front of you.

Fun Project: Find the Pileated Woodpecker that has been taunting me for years or find what's hidden like the photo below.

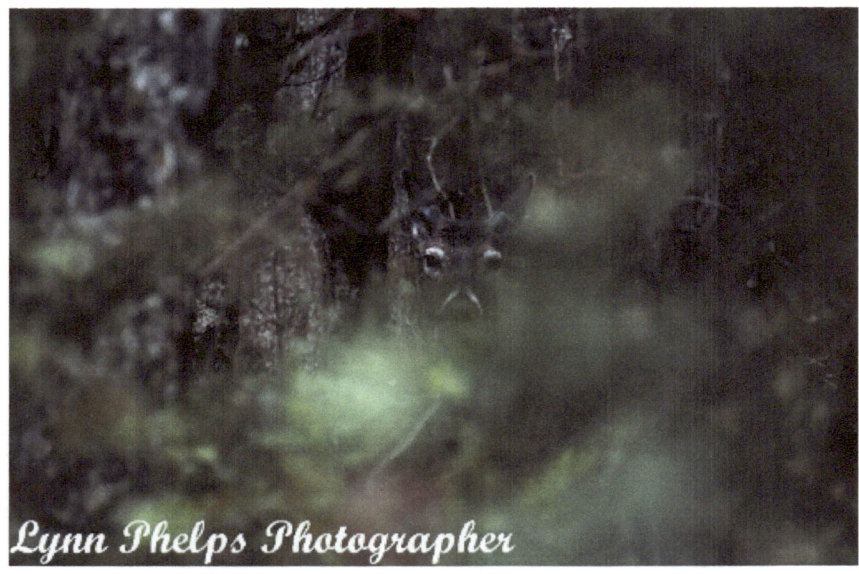

Capturing the Smoke

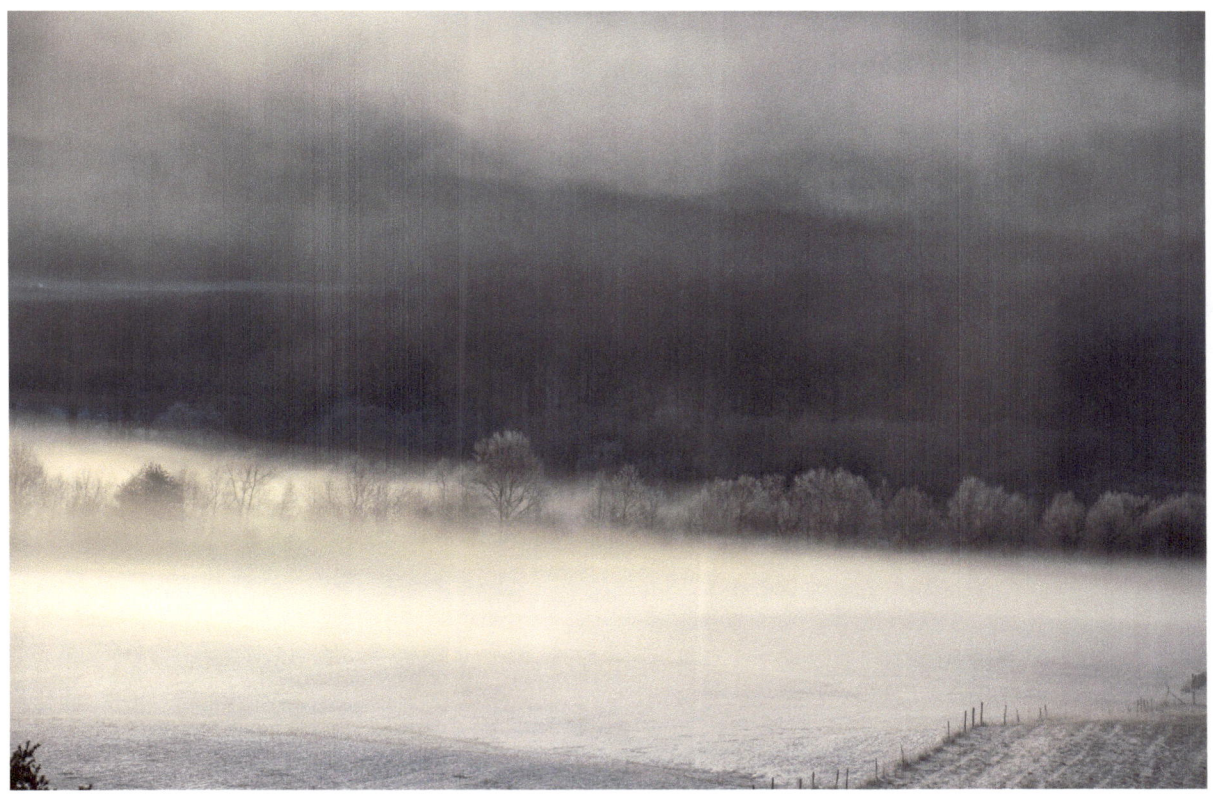

The mist can be beautiful and haunting. This photo was taken in the early morning right as the sun peaked in Cades Cove. There are so many great places to capture this beautiful misty blue smoke that forms from all of the moisture in the Smokies. The problem is that in any location you have mere minutes to capture it as the sun rises and causes the mist to start moving. It's actually very magical to watch. I take several sets of photos when this happens. I've found that using a wide angle is the most affective but I also use the 300 mm.

The first suggested place would be Cades Cove. You will need to be at the gate in line before the sun comes up. If you go through the week you will be almost alone and that can be a bit intimidating but so worth it. I've been the only person in the cove on occasion and the solitude can be deafening and priceless. Once you enter the cove your goal will be to get to the parking lot on the left on a slight hill. Don't worry you can always make the loop again but for now your goal is to get to that spot and capture this magical mist.

When you arrive, park and set up. A tripod is important for these shots. The rising sun should be slightly to the left of the center if you are facing forward.

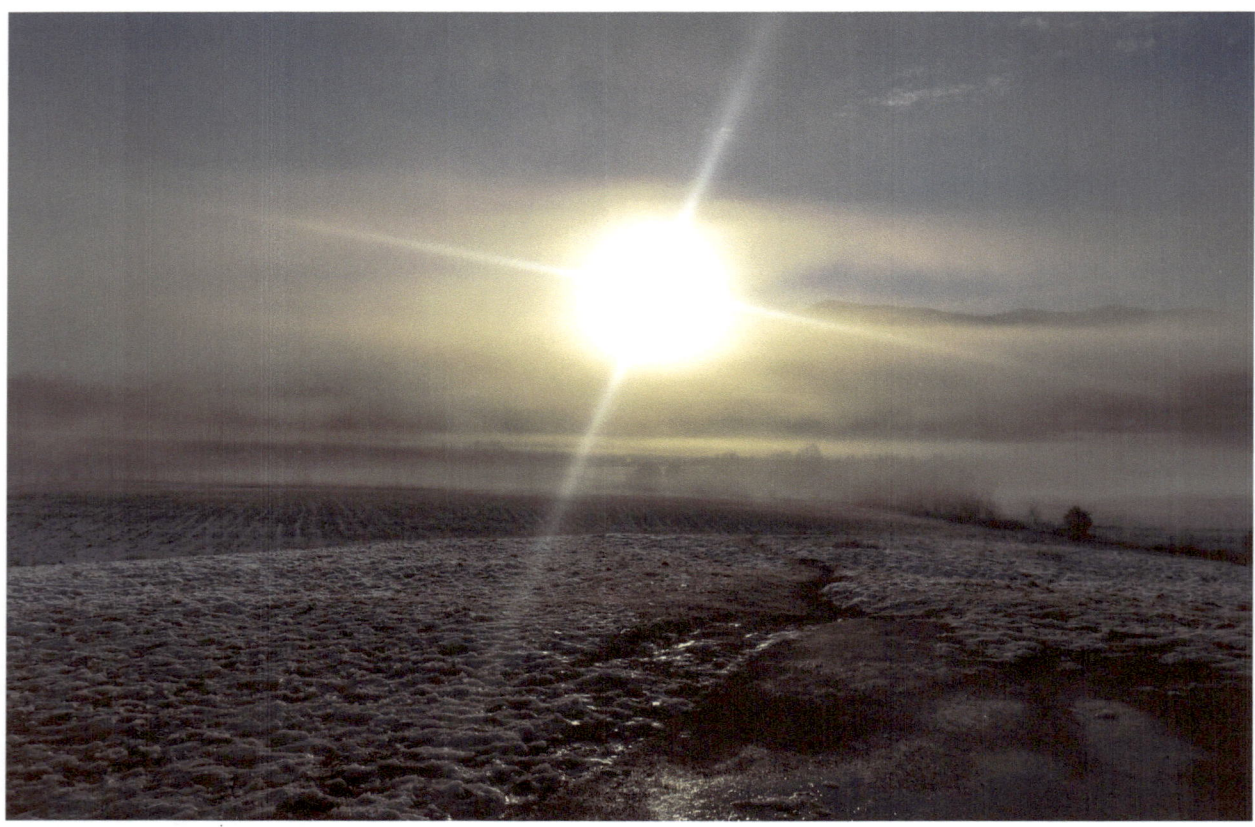

The next consideration for a location would be Clingmans Dome the highest point in Tennessee with a 360 degree view. A light paved hike to the top will give you a view of 6 states on a clear day. A clear day is rare. Even though it's an easy walk up be aware of the changing altitude, if

you have breathing issues you may experience some difficulty. Take a jacket, even in August it can be quite chilly up there, and early fall through late spring early morning can be cold. The place to capture the mist is not on the top it's actually in the parking lot. As the sun rises the mist actually begins to fall downward and it's spectacular.

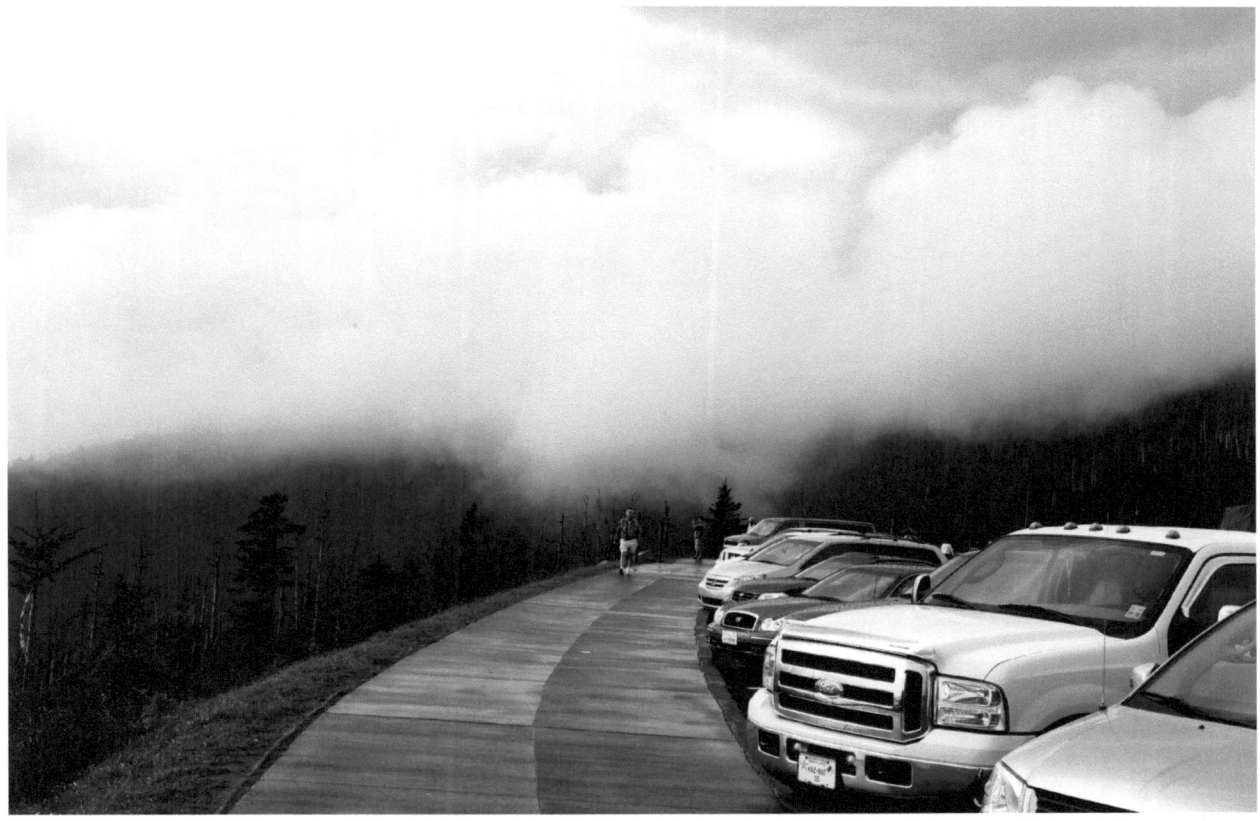

Of course if it rained the night before you will have such a large amount of misty fog that you may have difficulty driving up to Clingmans Dome. Check the weather, plan it out. If there is a thick fog it may be 11 AM before it lifts. Of course it's different from season to season. But if you plan it well it is worth it just a bit tricky. When in doubt stop by Sugarland visitor center and ask a ranger.

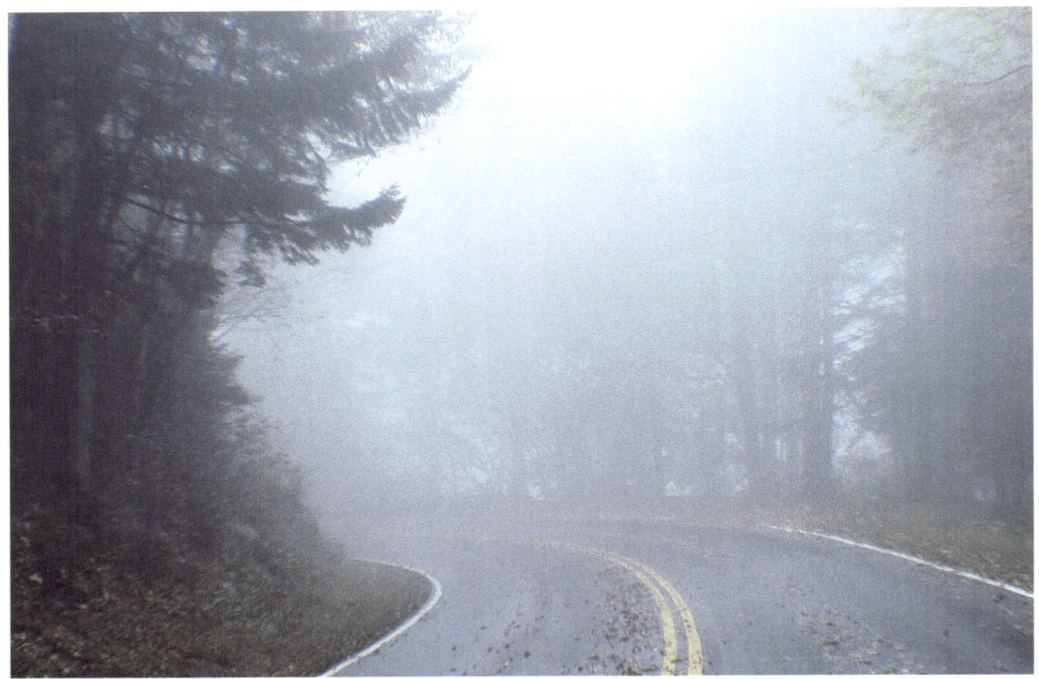

This fog wasn't all that bad but you really need more of a clear day to capture the mist. By the time I arrived I realized that I was way too early, it was almost noon before it lifted.

There are many other places like pull offs and over looks to capture the mist in the Smokies. There are also non park places like rivers, bridges, and farms. The lower the area the earlier you want to be there. The higher the area the later.

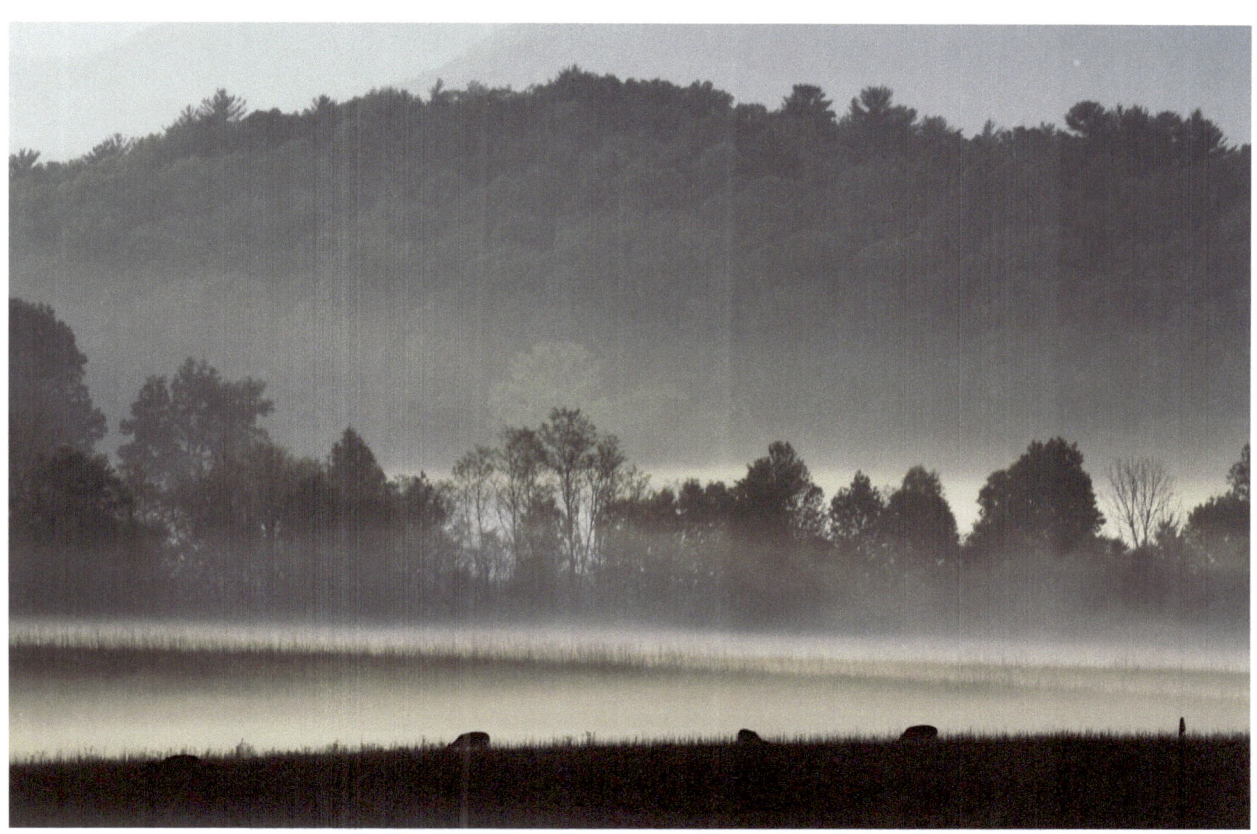

Fun Project- Use the mist to tell a story or create a feeling.

Capturing Sunrises and Sunsets in the Smokies

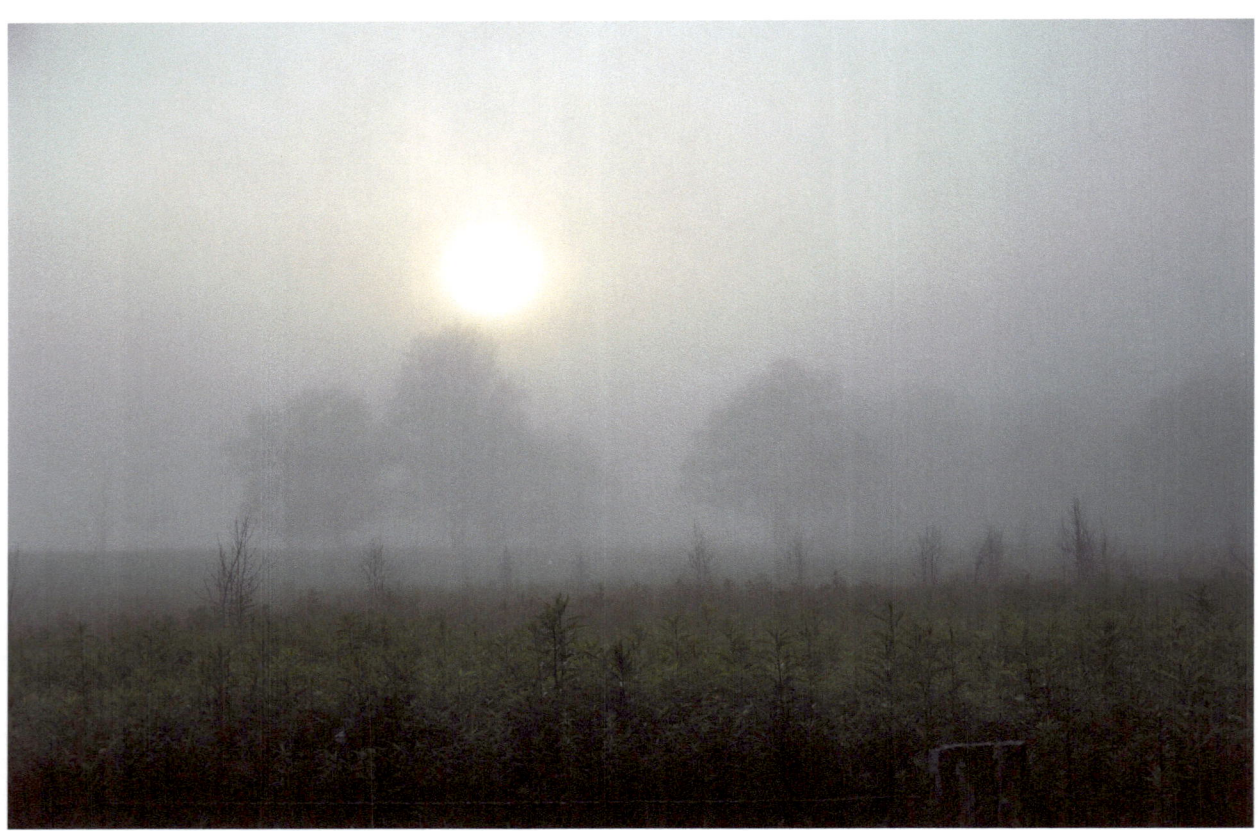

There's nothing quite like sun rising in Cades Cove. While there are not the spectacular colors that I'll show you in the next section it is peaceful and alluring. The sun is right there and rises quickly. As mentioned previously you will want to arrive early and get to your location quickly. If its color that you are after then you will want to go to Clingmans Dome but make sure that its clear and that it didn't rain the night before. I went early fall and it was frigid but so worth it. The sun will rise and the entire sky because an array of color, it feels so close that you could almost touch it. Other times would be winter. On a winter morning it feel like its minus 50 but it's clear

and crisp. Of course you could try at other times and if it's too misty then just plan on capturing the mist.

.

If you are seeking sunsets then travel to Clingmans Dome and walk up the short ½ mile paved walk (steep) and there are benches along the way for reasons. Most of the time it feels like you are walking in clouds but keep going and then wait. With luck and I am not guaranteeing it but with luck you will above a seas of clouds and witnessing an awe inspiring sunset. I don't have

photos to show you for this one, I can't make the climb (breathing) and (vertigo) but I've seen photos and heard stories and you should go. If you can't make it there don't worry the best place is Oconaluftee overlook just past Newfoundland Gap. Just sit and watch. It's also a great location for early morning photography.

Fun Project: Capture the rising moon. The rising moon before dark. The challenge will be finding the perfect location with perfect conditions. Cades Cove offers a full moon guided hike and stargazing event at various times. Check with them.

http://www.timeanddate.com/worldclock/astronomy.html?obj=moon&n=171

If you do not have access to the internet you can always pick up a copy of the Farmers Almanac

Capturing the Seasons

One of my biggest fears is sliding off an icy road and going over a cliff. To this day it is still terrifying to me. So knowing where to go and when to go is very important to me. Luckily for me and you the National Park will close roads that are not passable and they will flash a warning sign to remind you to be prepared for ice. When heading out for snow photos I always head to Cades Cove. It's a lower elevation. The roads are either clear with icy spots or closed. Dress in layers, take a thermos of hot beverage, and food. I wouldn't head in until after ten a.m. just to make sure the roads are clear and open.

You will find icicles, icy water scenes along the way as well as snow covered fields and old structures with a blanket of snow. If the sun is out then everything will glisten. I found exposure to be tricky but was able to adjust it. Bears are hibernating in the winter but you are sure to find white tailed deer.

Fun Project: Animal prints in the snow.

My favorite season but that's because I know all the back roads is fall. Fall in the Smokies is the busiest season. Prices go up, and everything is booked. If you are lucky enough to have made reservations in advance and equally lucky enough to have timed the colors then make sure you also packed your patience. Bumper to bumper is an understatement and one of the main reasons why we relocated. I'm not trying to discourage you just as a photographer I have found that it can be very frustrating. I prefer the back roads and Greenbrier for fall shooting. The above pgoto was shot at Greenbrier. Of course you won't get the patch work quilt that nature lays across the mountains but doesn't everyone get those shots?

It can be tricky if you want mountain shots of fall color. I have found it to be somewhat difficult to catch the entire mountain in full color. The 2nd and 3rd week of October are your best bets. But then again it depends on what you are after. If you what shots from the top those leaves turn first and fall first. So just keep that in mind. This photo was taken in late September so as you can see the color is just turning.

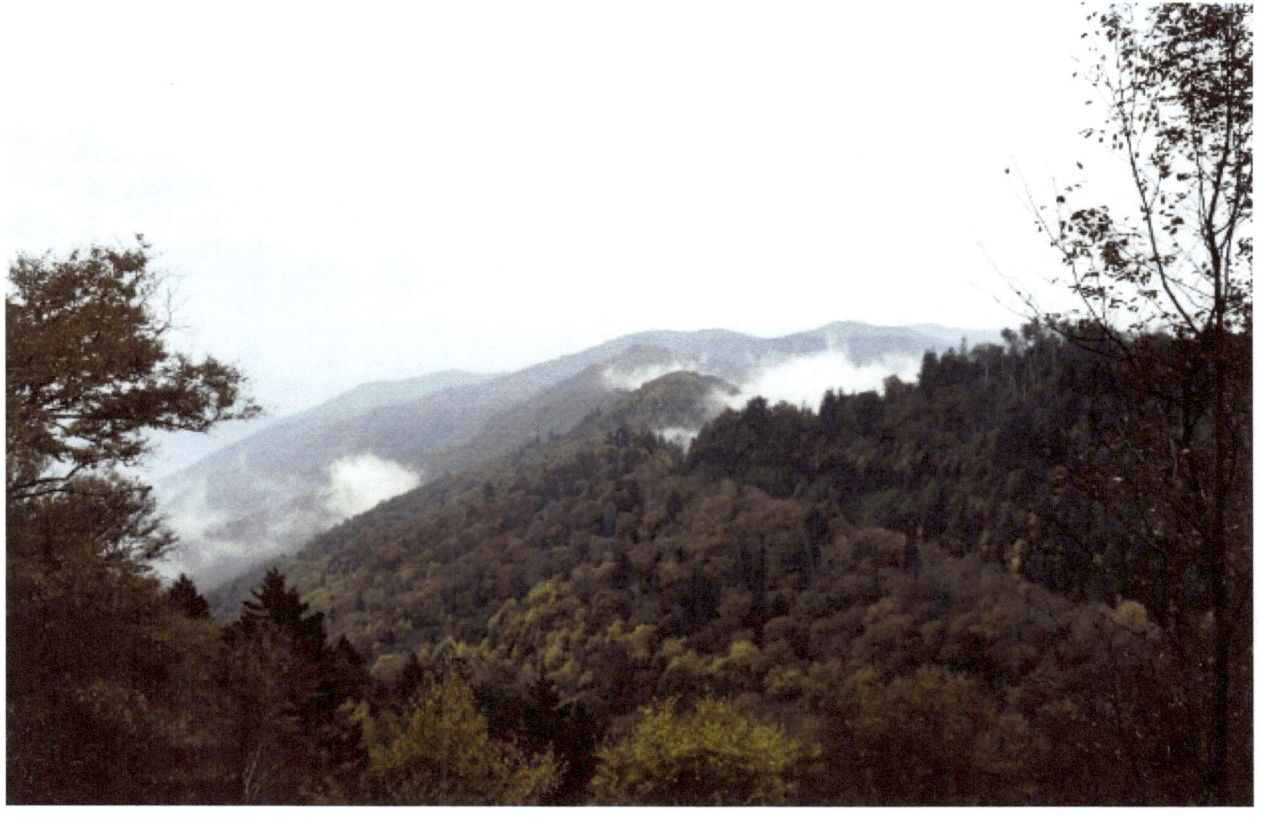

Winter in the Smokies is a magical experience for young, old, and very romantic. I remember when they use to roll up the roads and cut off the street lights. Then winter fest was born.

There isn't much to say here, it's one of those you can't miss it because they are everywhere moments.

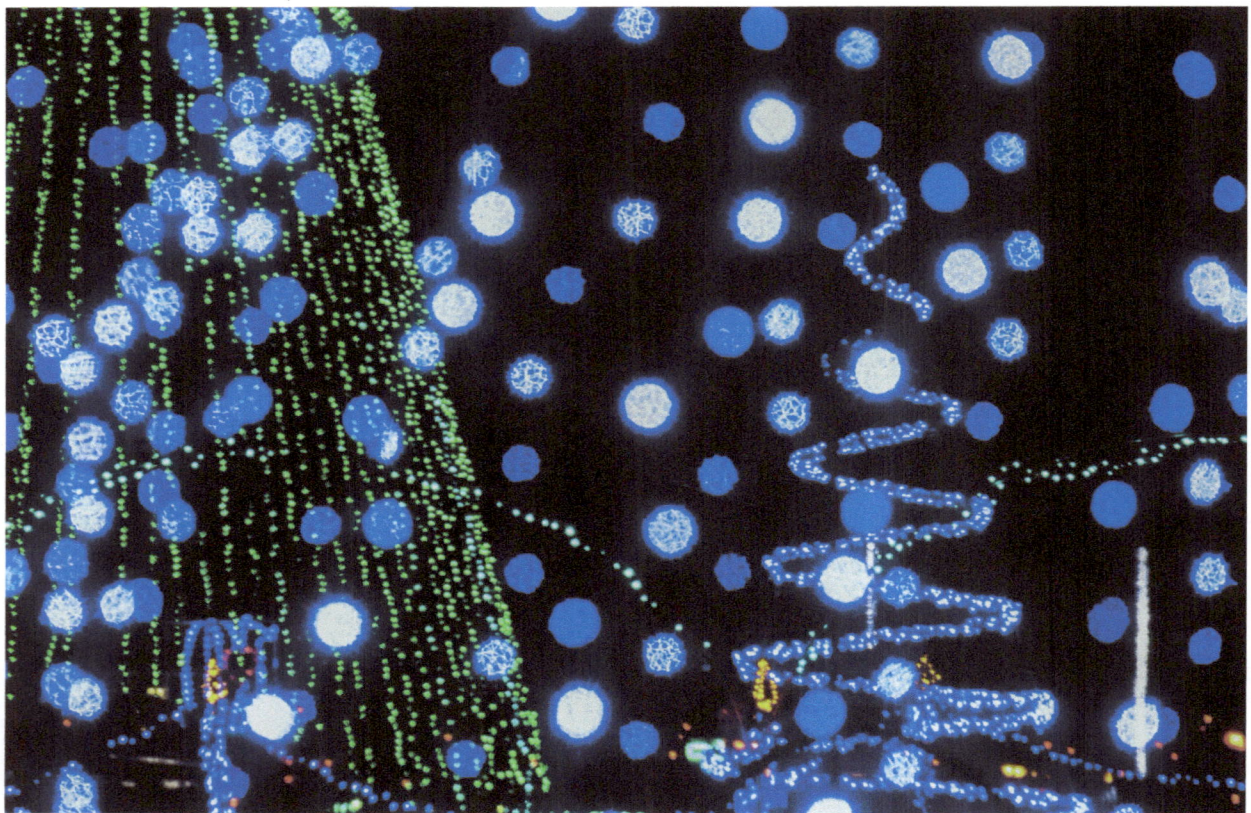

There are lights for miles. Pigeon Forge, Gatlinburg have lights down both strips, each sides and in the middle. Patriot Park beside the Old Mill in Pigeon Forge has a light display and there is also Christmas Village .

Fun Project: Try Bokeh

Spring in the Smokies is delightful. With the season of wild flowers, to the dance of the fire flies both as mentioned earlier, along with new baby cubs. It's also mating season and animals are become very active after a long winter.

Wild flower season is from early may until Late June and even in July. Then through late summer and early fall. All depending on weather of course. You can find a schedule of when they bloom in the resources section of this book. I'm not a wild flower enthusiast but from what I understand they begin with a list of all the different wild flowers and they find them, like a treasure hunt and photograph them. During wild flower season you will see folks standing really close to rocks and embankments with cameras. This is probably what they are doing. There are 1500 different wild flowers in the park and the best way to find them is by hiking.

Don't forget about the other really cool things like mushrooms, pine cones, mussels, and moss.

Tip: If you observe people digging plants in the park, report the activity to the nearest ranger station or call (865) 436-1230

Spring is also a great time to hike and to capture water falls, rivers and streams especially right after it rains. One of my favorite spots is called the "sinks" it's right off of River Road, no hiking required. Old folk lore is that there isn't a bottom under the "sinks". So be careful. All kidding aside people have died there.

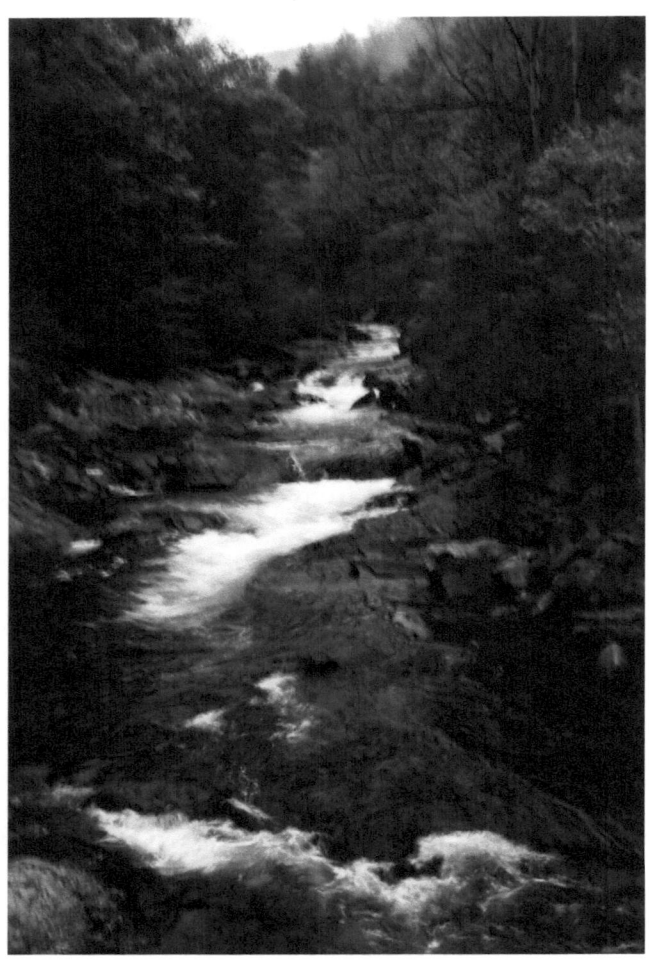

The photo above was taken across the road from the sinks, a place often missed. A bit down the road you will find Miegs Falls. It's also visible from the road. **Tip:**

The woods, rivers, falls, trail are shadow filled and dark. Make sure to bring your flash.

You can find more information regarding water falls by visiting the link below.
http://www.nps.gov/grsm/planyourvisit/waterfalls.htm

Tip: Falls and rushing water means misty conditions- protect your gear.

When visiting the mountain areas the temperature will be about 10 degrees cooler and either humid or misty or both. Equipment can be sensitive to temp changes going from hot to car AC to mist moist and then cooler temps. During my last visit I completely forgot to remove my polarizer and sure enough by the end of the day it was locked on tight. I've found that a cheap white Styrofoam cooler can become a temperature decompression chamber for your camera, and they are water proof. You may not need to go to these extremes but they are worth a mention and what better place to cover it than the chapter about water!

Camera settings for magical water photos will depend on what you are after and your camera but I found that for my Nikon was f16 and an ISO of 200 with a polarizer on (because it was stuck not that it was needed) . Although I had to play with it a bit because of differing conditions. A light weight sturdy tripod is a must. I also found that a wide angle lens gave the most dramatic shots verses my usual 70-300 lens but I shot with both because I wanted some close ups of water splashes.

In addition to finding fantastic places to shoot water you may also find old walking bridges, wood bridges, and the remains of old houses.

Signs of life that once was before the park was established in 1934. Prior to that there was about 1200 land owners in the mountains.

Fun Project- Since you will be around water click here for the Salamander check list and

start looking.

http://www.nps.gov/grsm/naturescience/amphibian-checklist.htm

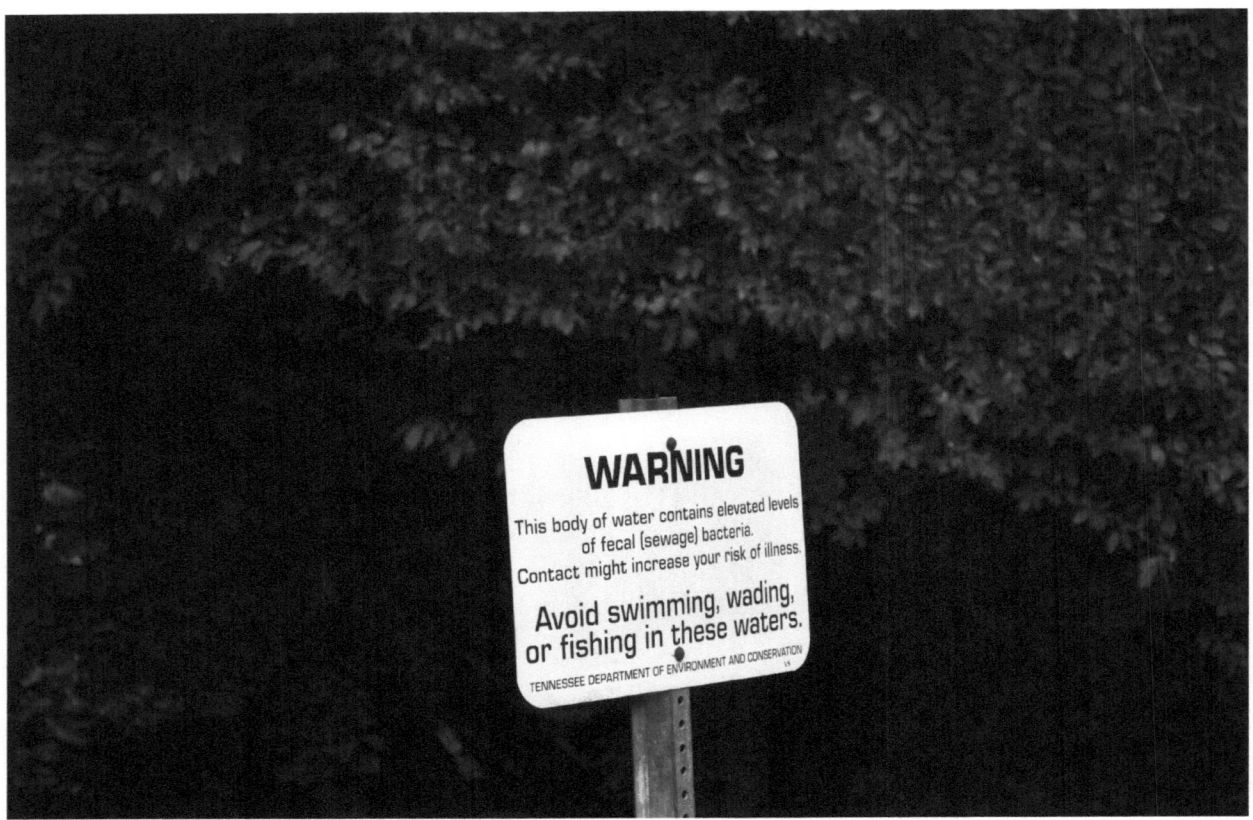

This sign is a result of some writing that I did about 15 years ago. The sign is still up today and can be found along the spur road that runs between Gatlinburg and Pigeon Forge. They are hidden. I want you to be aware that they exist and apply for most water even if the water if flowing and there isn't a sign. Water in places like Greenbrier isn't contaminated but look don't drink it. The same applies on top of the mountain, it should be just fine but I wouldn't drink it.

Onward……

Ramsey Cascades is not only the tallest waterfall but the trail gains 2000', and it's named after one side of my family. My grandmother grew up there. I often stand in amazement just think in about how neat it was to have played in Greenbrier.

Tip: **Do not attempt to climb to the top of the falls. Several people have been killed trying to do so. Don't hike alone.**

If you are not up to hiking to Ramsey Cascades still go to Greenbrier. Greenbrier is one of if not the very best places in the Smokies. Rushing water, huge mossy rocks, wooden bridges and plenty of opportunities to explore. Rainbow falls is another popular area it's located on the Nature Trail. The nature trail is a driving tour with places to park and hike. After you drive through the first half it will change and there you will find the "Place of a Thousand Drips". Its road side and after it rains the water fall splits and runs down several rocks. Ill pickup my discussion on the Nature Trail again under Structures.

I'll have a link to a park guide at the end of the book so that you can locate all of the falls. One of the best places to go to play with capturing water is called the "sinks". Both sides of the road are fabulous. The sinks is located to the right of the Sugarland visitor's center on Little River Road towards Cades Cove. It isn't a short drive nut a nice break on the way to the Cove from Gatlinburg. Please be careful, you can pull right up to it and park, but people have died there.

I realize that I'm adding in a lot of warnings in this section, but I want you to get great shots and stay safe. I know how it feels to be so excited that you forget everything that you know, or to stretch your limits to get that perfect angle. I get it. Be safe.

Fun Project: Find something interesting in nature like this tree hand grabbing a rock.

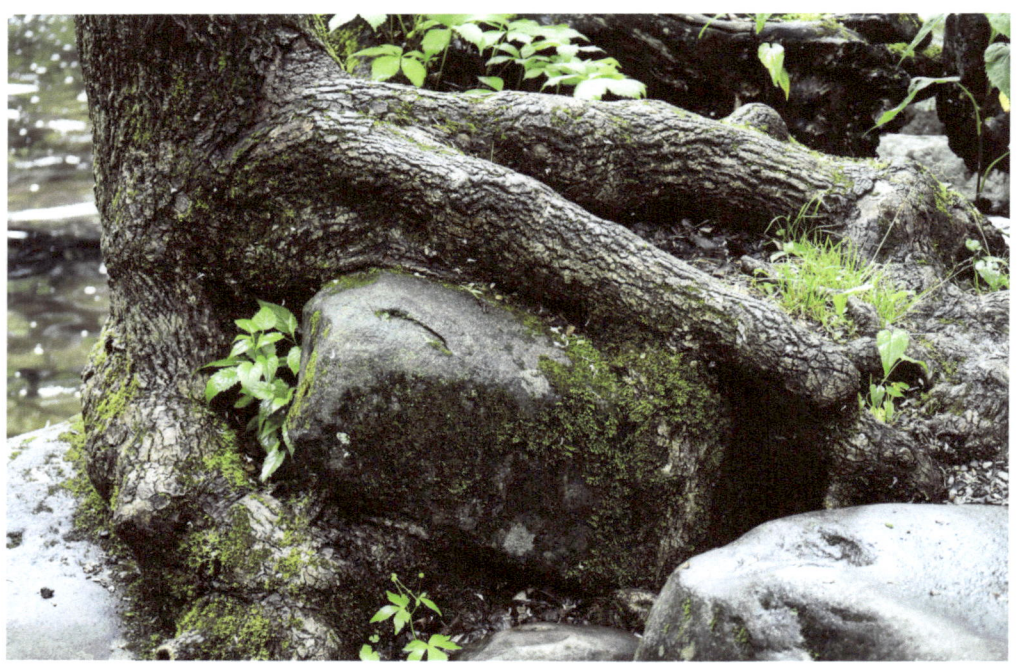

Capturing History

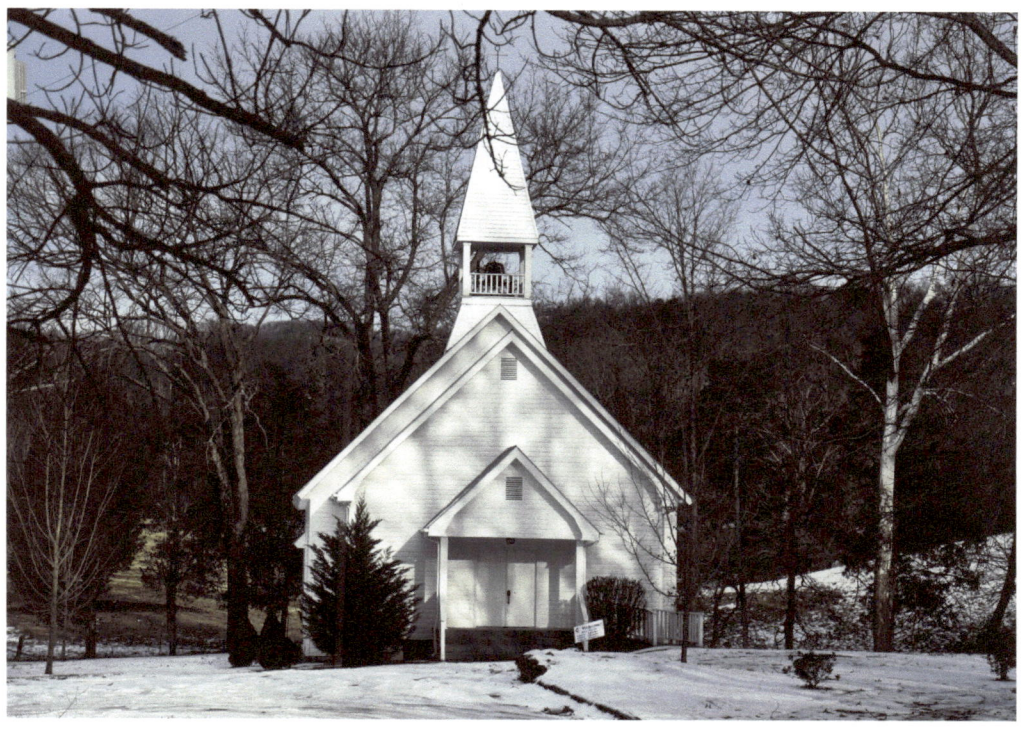

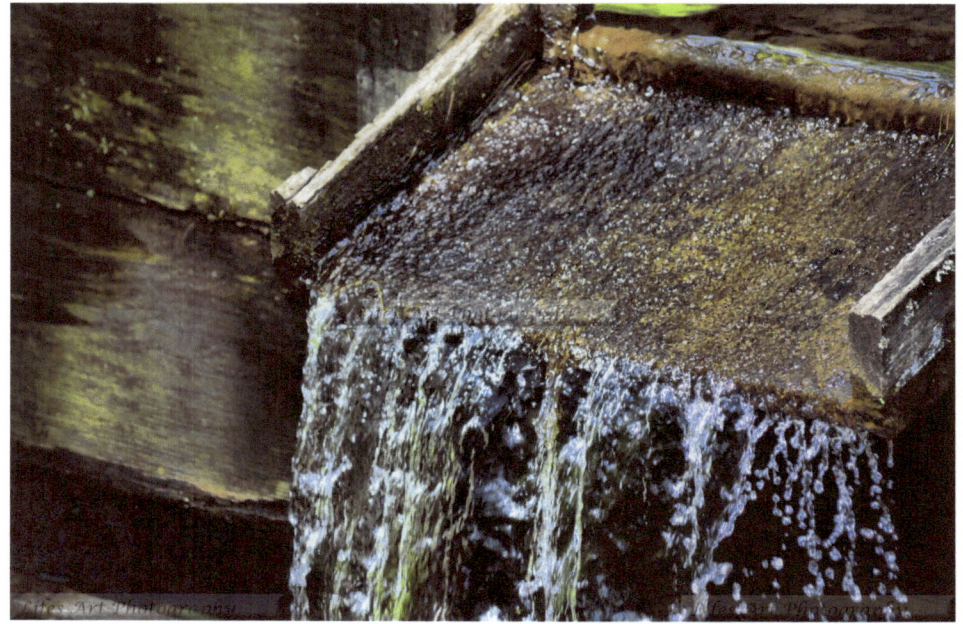

There are so many neat structures in the area, both within the parks and on the back roads. Since this isn't a how to but a where too book Ill skip right to the where too. The above church is located in Jones Cove. You can find the very lengthy directions by googling

them. Another area with old houses is called Pearls Valley. They filmed the movie Blaze there. If you are up for a long drive then you won't mind trekking out to these places. You will certainly find a lot of Tennessee color on the back roads.

However, if you want to stay closer in then there are plenty of places to go to find the original homes of the original settlers. Cataloochee and Oconaluftee are a couple of places with historic structures. You'll find over 90 churches, structures and buildings that have been preserved within the national park areas. The nature trail located in Gatlinburg at traffic light #8 . The first half is wooded the second half has a few really great homes and a grist mill. Which is where I took this photo .

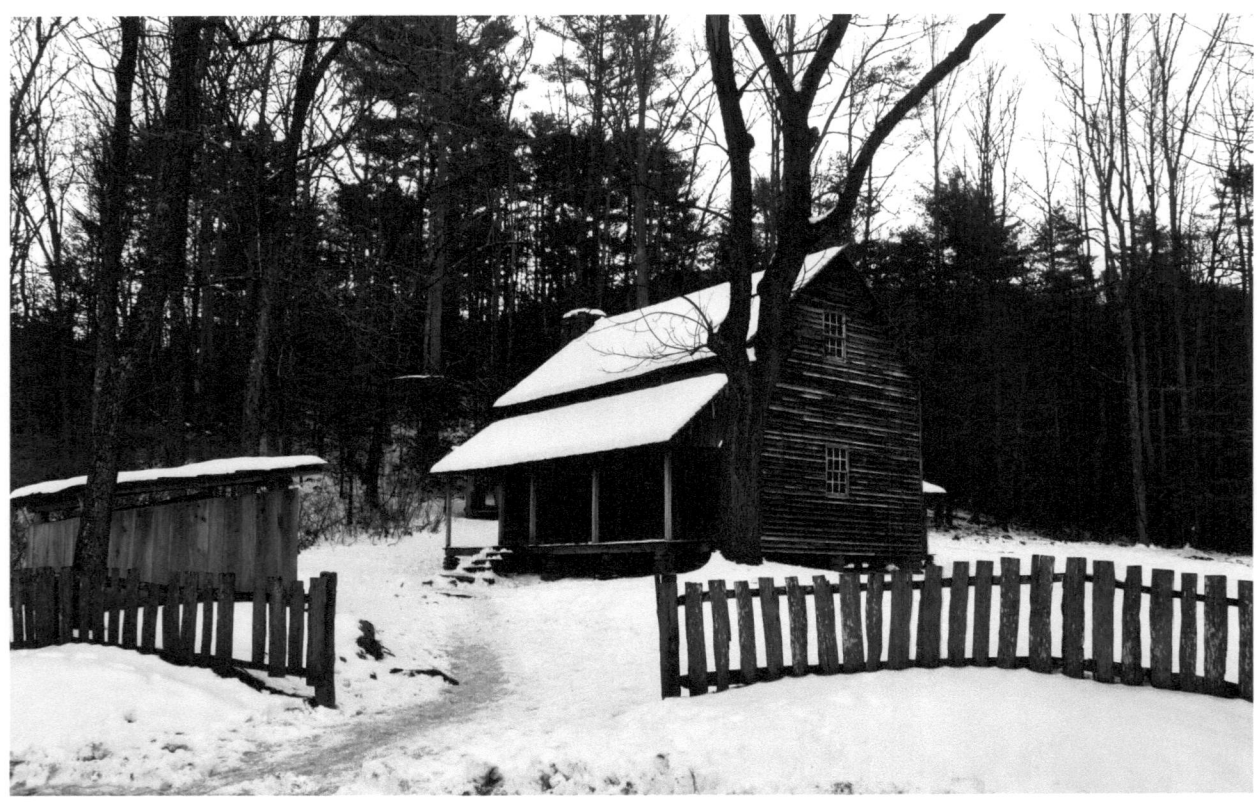

Cades cove of course has many old homes and barns

Capturing the Night

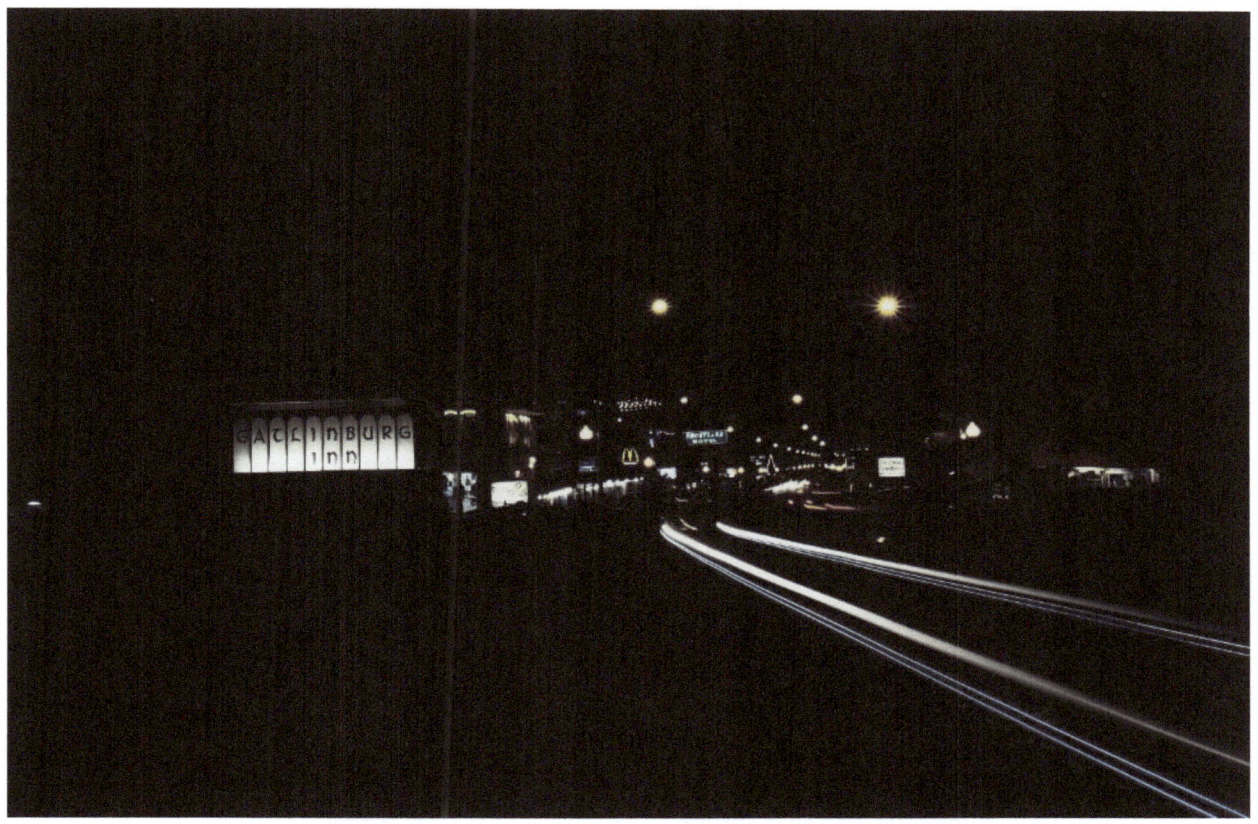

Night time in Gatlinburg is my favorite spot. From car trails to star trails there are plenty of things to get creative with. Even the cabin you are staying at can be creatively enhanced for a night shot. Venture out to Pigeon Forge and capture the Old Mill, or one of the other water ways. A shot I have yet to capture is the full moon over the Smokies. Timing and planning is everything.

Capturing Reflections

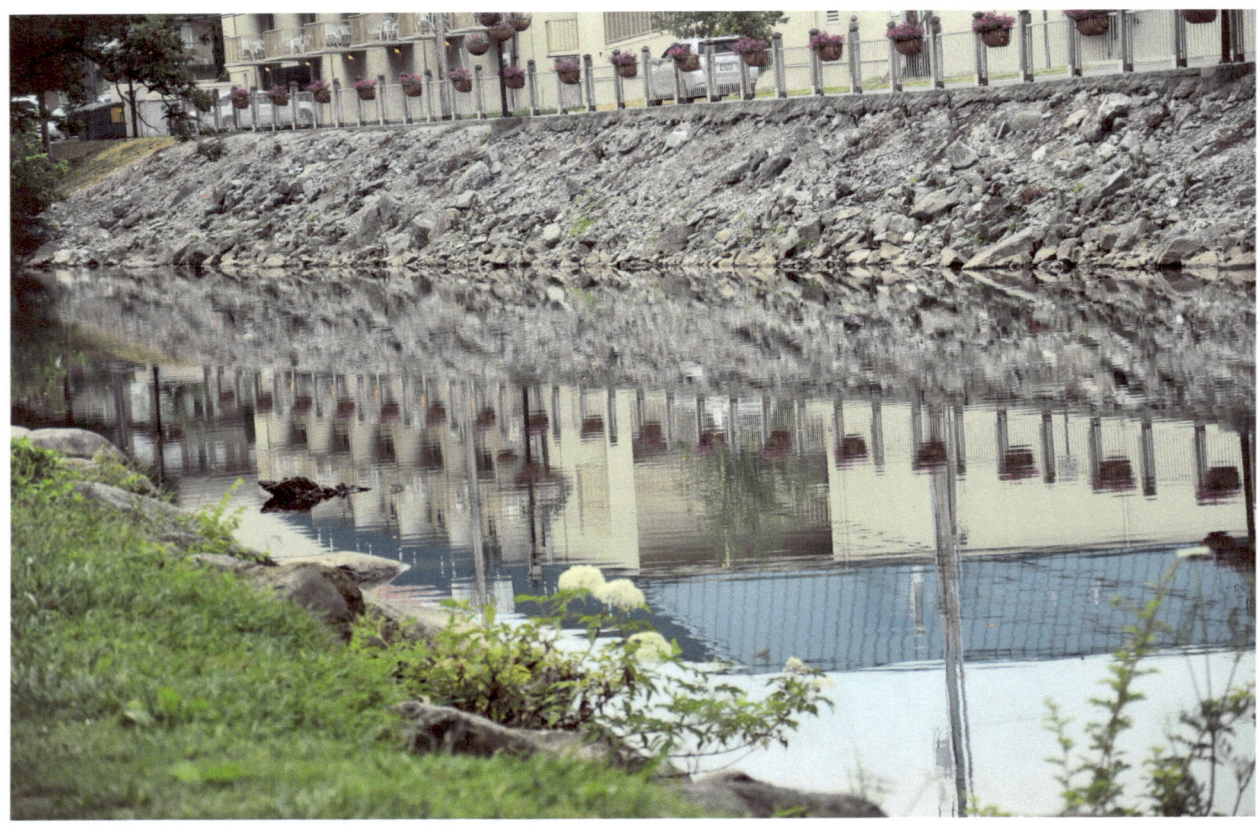

Just a short mention here- don't forget about reflection shots. There are some fantastic locations for capturing reflections just about anywhere so keep it in mind. Enjoy!

Resources

Galleries

Touring Galleries of Local photographers is a great way to feel inspired.

- William Britten Gallery located on Glades Rd in Gatlinburg
- Jim Gray Gallery in Gatlinburg

Restaurants

The best places to eat in any tourist area is where you see local car tags.

- No Way Jose's Cantina in Gatlinburg
- Cracker Barrel Pigeon Forge
- Best Italian Gatlinburg
- Smoky Mountain Brewery Pigeon Forge
- The Partridge & Pear Restaurant
- The Donut Friar located in The Village in Gatlinburg

Lodging

- Carrs Cottages Gatlinburg
- Bearly Rustic Cabins Townsend
- Hearthside Cabin Rentals Pigeon Forge

Maps and Guides

To purchase printed maps
http://www.nomadmobileguides.com/examples_of_travel_apps/gsma/
Trail Views
http://www.naturevalleytrailview.com/smoky-mountains
Water Falls

http://www.nps.gov/grsm/planyourvisit/waterfalls.htm
Wild Flowers

http://www.nps.gov/grsm/naturescience/wildflowers.htm
Emergencies

- **Ambulance**
 453-3200 (Sevier County)
 436-5112 (Gatlinburg)

- **Police**
 436-5181 (Gatlinburg)
 453-9063 (Pigeon Forge)
 453-5506 (Sevier County)

What to do if you see a bear

http://www.nps.gov/grsm/naturescience/black-bears.htm

www.ingramcontent.com/pod-product-compliance
Lightning Source LLC
Chambersburg PA
CBHW050359180526
45159CB00005B/2078